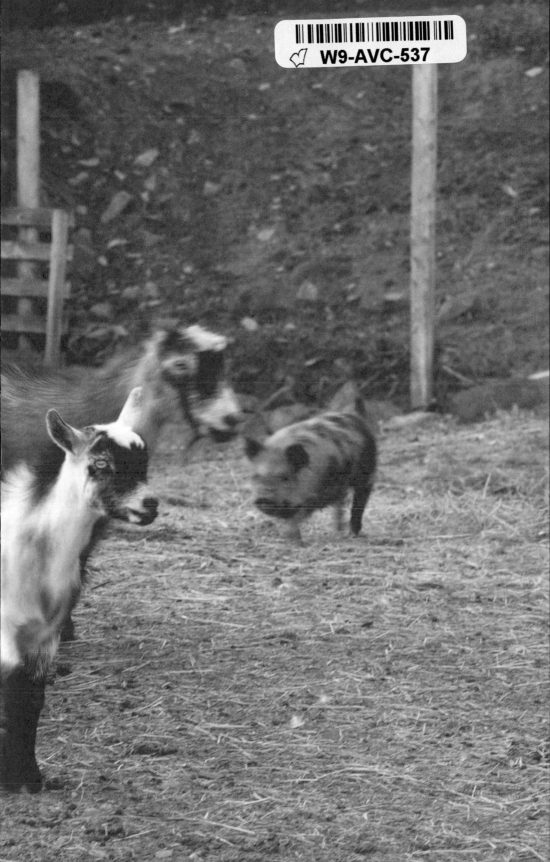

love from the Misfits

Art, photography by Katherine Dunn
katherine@katherinedunn.com
www.katherinedunn.us

Cover Art by Katherine Dunn
Design Assistance with Cheryl Watson

Printed in Canada

Misfits of Love

Healing Conversations in the Barnyard

KATHERINE DUNN

OF APIFERA FARM

APIFERA PRESS

Dedicated to

Robert Louis Dunn,
my father who lives in the wind

and

Old Man Guinnias,
a very fine goat who floats by in the clouds

Table of Contents

I find a moth.
The wing is torn.
I shelter it in a
flower pot and sing
a song about the sky.

"It will be okay,"
my child voice says.

❖

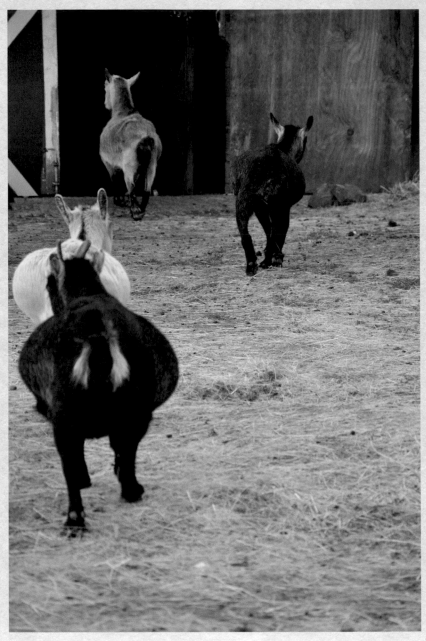

In the Beginning

{There was an end}

A crippled goat unable to stand upright and his pig companion, squat and malnourished pygmy goats, an old donkey kept as a brood jenny in a snowy field of stubble subsisting on straw, the semi-feral cats retired from the woods to the hayloft, and roosters who rambled over for the arms of Old Barn after being dumped on a rural road—these are just some of The Misfits. Not good enough for a working farm and deemed unadoptable by most, I felt instant camaraderie with each, perhaps because I too have always felt more Misfit than mainstream.

Holding us all up is the farm, Apifera, with her working flock of sheep, a big red horse, and fruit and vegetables birthed from her dirt. Rabbits, turtles, deer, chinchillas, and even moths, sense refuge here when wounded.

But as the barnyard filled with needy animals, an elderly creature I'd known since my birth—my father—was nearing the end of his life far away from my farm. The daily caretaking of my Misfits helped them prosper and brought me a sense of purpose, but it was much deeper than that. I found my work with them helped me grapple with everything that comes with the death of a parent.

As I massaged their old joints or communed amongst them without words, a remarkable thing happened—that silence created an internal, safe space for me to float with memories, fears, and questions. The animals became conduits of powerful messages that left me with a better understanding and compassion not only about my father, but also about myself.

And it all started with a very elderly goat.

His name was Old Man Guinnias.

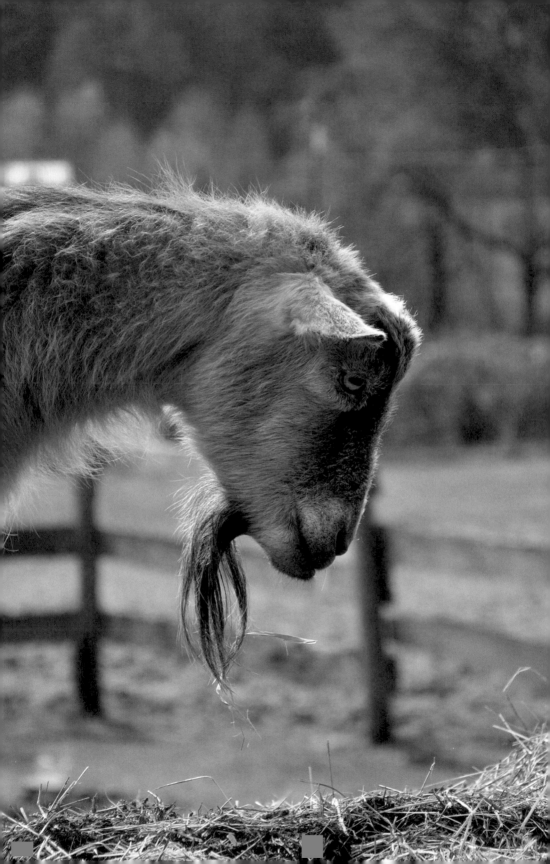

He'd been the 4-H goat of a child for many years. But the boy grew up and the now middle-aged goat grew old and lonely. He began to conquer the gates and fences in order to make his way to the front porch, where he sought sunshine, flowers, and companionship.

The people of the house grew tired of his droppings and flower eating and had no time to commune with an old goat, so they took him to an animal rescue and left him. He was fifteen.

Soon after, Apifera discovered he needed a place to call home and he became the first old animal to be adopted into the barnyard. He arrived crippled from foot neglect and was very thin.

"Stay as long as you can, Old Man," I told him.

Looking back, I think I was also talking to my father who had just entered hospice back in my homeland of Minnesota.

"The complexities of another's life are what led me here,"
the old goat said to me.

He was thinking of the young boy who had raised him for 4-H some
fifteen years ago.

"He adored me, but adoration is much more fickle than love," he
paused, "and fleeting."

Conversing with a goat can be a brief encounter, a passing by of,

 "Leave a few apples on the tree for me, please,"

or it can be an ongoing dialogue where information is extracted
slowly, over time, days even.

The morning sun had soaked into the cement retaining wall by the
old barn for at least an hour. The old goat hobbled to the wall and
pressed one side of his body against the warm grey stone. His front
shoulder is bent from crippling and his feet are turned on their sides
from years of neglect in his former life. Any movement requires a
shifting of good legs to bad, creating imbalance, but a quick head
bobbing always seems to get him steady again.

Guinnias' 4-H boy quickly learned that a bike got him farther than a goat, and the bike eventually was replaced with a car. The car took the boy to new places where he could fish, dance, drink beer, or be a boy without a goat.

"I would have traveled with him, but he never asked," the old goat said.

As he chewed some cud I sat in silence with him, watching the wind dance with chicken feathers, first slowly lifting them, then dipping them in a dramatic tango dive.

I thought of the feathers placed neatly in my father's felt top hats he often wore. Who shed those feathers for his hat, I wondered.

Arriving at Apifera Farm at the age of fifteen, Old Man Guinnias was the first elderly creature to be adopted into the barnyard and was welcomed by the century-old arms of the barn. He spent his first day under the watch of the Apifera sky, surrounded by chickens, donkeys, and a horse in the near distance.

He slept that first night in his own semi-private suite—with fencing separating him from younger goats for safety, but allowing nose sniffing for comfort.

Even though crippled, he held himself with dignity, like any elder statesman with a past of accomplishments and personal experiences to fill a book. Like any keeper of secrets, the feelings and memories he had tucked away deep into his own skin and heart could bring him acute moments of loneliness.

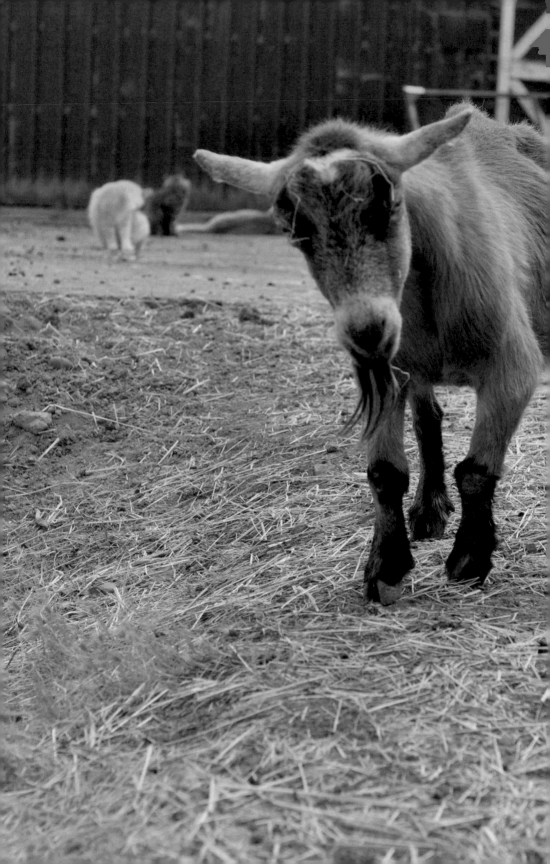

"They usually come to me in the morning, after dreams have left,"
he told me.

His boy had left home for college and the parents eventually drove
the old goat to a rescue and left him there.

"We just got tired of him coming up on the front porch," they wrote
on the intake papers.

"If they'd asked, I might have considered sunning elsewhere,"
the old goat said to me.

Old Man sat with his sagging eyes looking off into the tree line,
stoic but with a sense of melancholy. His expression reminded me
of something my father said nearing the end of his life,

"You get overly sentimental when you're an old man because . . . "
but he didn't finish the sentence.

The old goat's given name was Guinness, like the beer, but when he
arrived at Apifera it was apparent he was much too dignified to be
named after hops.

"Most people don't take time to commune with the creature and hear
the name inside them," he told me as I announced I had altered his
name for him.

When one of his barnyard mates is ill or breathes a final gasp, Guinnias is in the background, taking note of the procedures, smells, and sounds. I carry an old worn goat body to the nearby pumpkin patch where all the fallen Misfits are buried. He stumbles through the pumpkin vines with me, sniffing the air that hovers above the same place he too will lay amongst dirt and worms and comrades of former days.

"Please face me toward the sun, and place my ear tips in a way so I can hear the sing song of the barnyard," he said calmly one day as we harvested pumpkins.

The wind chimes rang in the distance again, perhaps reminding him of the warmth of a front porch of yesteryear, but he did not look wistful. He had everything he needed on this side of the barnyard gate.

He had arrived so crippled and thin at age fifteen and I simply wanted him to have a good few months or year to live out his life. But he was now going on twenty.

"Maybe he'll never die," I told myself.

"Guinnias," his slightly revamped name, pronounced Guinn – ee – us, conjured up an image in my mind of him walking the hillside in a tweed jacket with leather elbow patches, carrying a walking stick and going ever so slowly, stopping only occasionally to watch birds through binoculars.

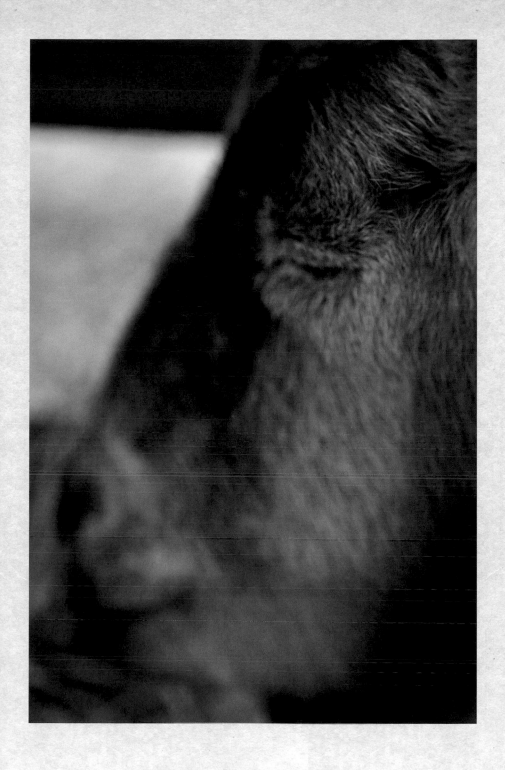

"He never came by again after he went off to college," Guinnias said, speaking once again of the boy who reared him up from birth. "He must have had reasons why he didn't return for me."

Abandoned in old age, because he stumbled to the front porch too often to seek out sun and companionship of any kind, be it cat or human.

From a distance, the wind chimes on the front porch jingle and sing in the wind, making the old goat's ears prick forward.

"There were sounds like that in my old home too," the old goat mused.

He now had everything he needed in his barnyard—food, shelter, and earth soaking up the sun to be his warm cushion. He had companionship when desired but also had a private retreat for naps or deep thinking during cud chewing. He partook in the daily and nightly barnyard routines and in time he gained confidence that this daily routine was now his world, it was how he would live out his years.

"I fall more now, it's those rocks that get me sometimes," the old goat says with an uncomfortable glance.

It reminded me of my father telling me in his final elderly years, "Getting old is not for sissies."

He's an old goat, but he's a lot like any elderly person left behind, or shuffled off without being asked, to live with a distant Auntie who has one-level living and a spare den.

Old Man Guinnias has outlived many of the younger elders of Apifera's barnyard. Each year as a new winter emerges, I wonder if this will be the winter his body will finally fail him. But each year, he plods on like an old vet and reminds me I'm not in charge of anything.

It just seems so strange to know he will disappear, like the chicken feathers that eventually blow so high and far they merge with the river water a mile down the road.

"I am fading into earth," he said.

And Old Man Guinnias Did Die
{And so did my father}

On the spring morning my father died, he was far away, safe in his
home with his wife and dog nearby. That same morning, as I did my
barn chores, my skin felt electrified, as if his molecules were touching
me through the wind. While I'd lost a father, I still had Old Man
Guinnias—somehow I felt the two were connected. Guinnias had
been falling often and was reaching a point where he could no longer
rise from a fall—a deadly consequence for a goat. My father's legs had
crippled him in the end, too, giving him constant pain. I couldn't help
him, but I could help Guinnias.

In the end, Guinnias fell in the barnyard several times. But this time
his cries for help were much more desperate. He couldn't fight
anymore. He always leaned into me for support and scratches, but on
this day he bowed his head down on my lap and shut his eyes. I held
him a lot that day, shared memories and feelings, cried, and said all
I needed to say. I told him I would do right by him, and planned to
call the vet the next morning. But Old Man Guinnias went out in his
own way, dying in his sleep that night. Perhaps he did that for me.

I dug his grave and buried him with love letters, cookies, and chicken
feathers to carry him on his way. I wept over that grave for that old
goat, but the tears were also for my father, for I never had a daughter's
proper farewell, nor did I have the dirt of a grave to touch. Tending to
Guinnias' body somehow helped me comprehend my father was really
gone—a final gift in and of itself.

Guinnias is buried in the pumpkin patch, silently feeding the worms.
Each autumn, the large orange fruits arrive exuding his essence. ❖

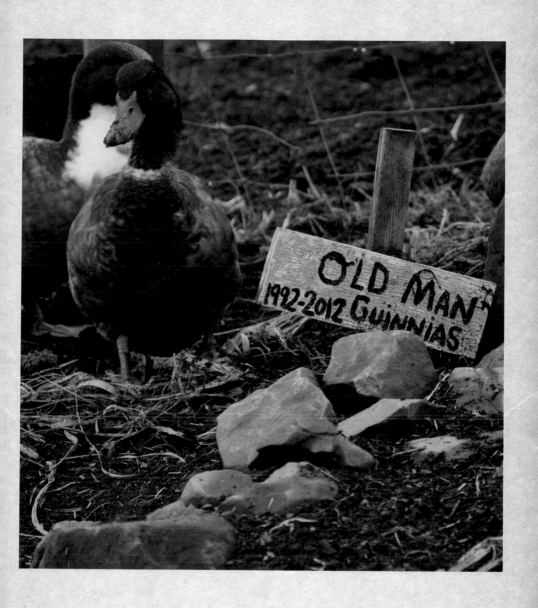

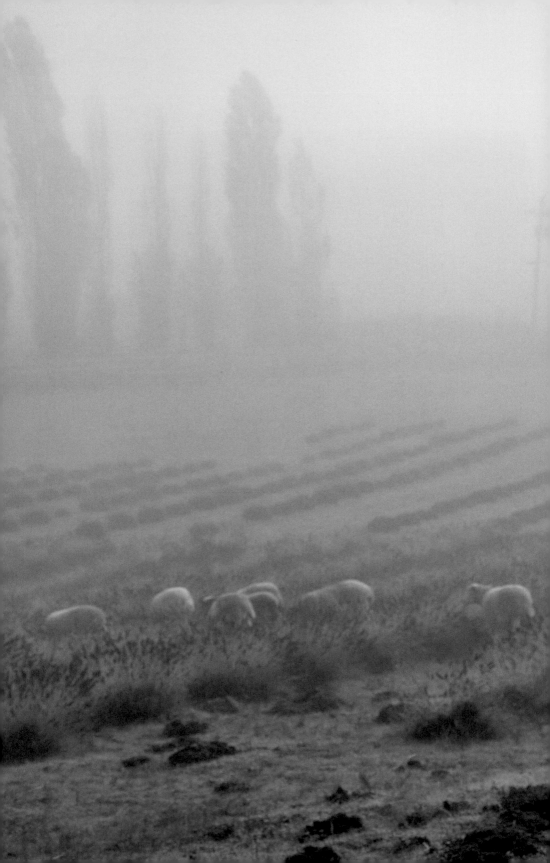

Day after Death
{There is life}

The next day, the fog comforted the farm, blanketing palpable human sorrow. The barnyard had a missing member, but there was no weeping amongst the creatures.

The flock went about with their daily routine of eating the grasses and fertilizing the earth in the lavender field as columns of tall trees stood silently in the big white.

I returned to the barnyard, bustling with sound—goats and horse chewing in rhythmic pulses, the pig snorting through dirt, ducks and the old goose splashing in buckets. The rich scent of dirt rising above the compost, "black gold" as we call it, reminded me I was standing on land that was both nurtured for, and by, all the animals.

The chickens were busy in the pumpkin patch, picking out worms and grubs. Some stood on the fresh grave of the old goat, not in mourning, but in a complete state of chickenness, scratching and chatting amongst themselves like ladies at tea.

"There is life everywhere," Old Barn whispered to me as I grabbed some hay from her arms. ❖

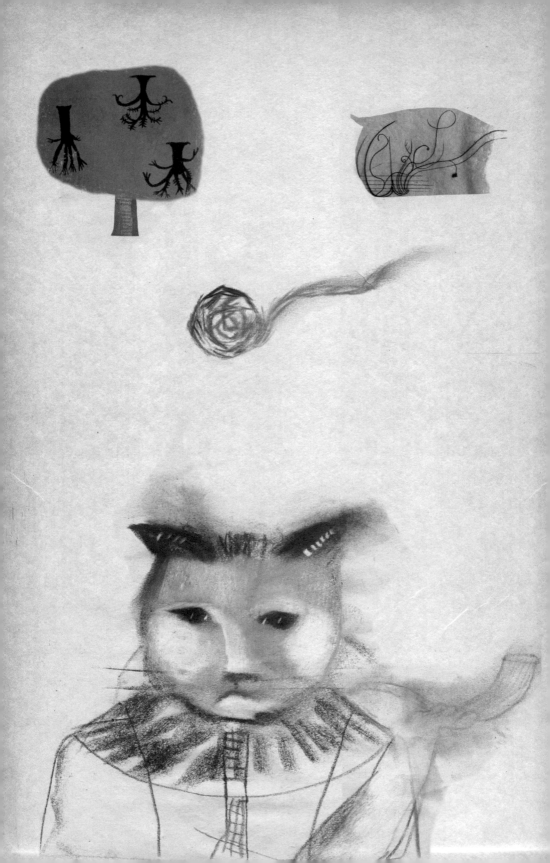

Cat and Mouse Interlude
{Come back}

But I still yearned to
see my father. Certain creatures
took on his personality for me.
I drew a wandering cat, but it
looked like my father to me.

So I gave him fruit trees,
a light breeze and one of his
favorite pipes to smoke.

Unconsciously, I erased his
pipe until only a shadow of
it remained.

"His skin just dissipated,"
 I thought,
"like erased pencil."

In the end his legs were very thin — like a little mouse. When mice visited me during my daily chores, I allowed myself to greet them as I would my father. I drew mice over and over.

In time it became very clear to me — no matter how many mice came into my life, none of them could bring my father back.

But only his body was gone.

❖

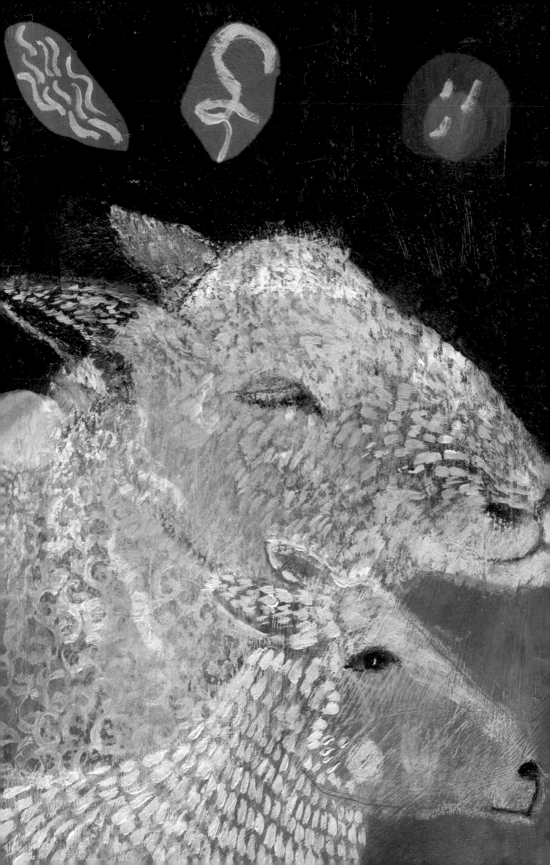

Memory
{Acceptance}

Snow clusters in herds on the backs of my sheep. My memory drifts back long ago to a walk with my father: As a big pine tree waves to greet us, flakes fall from her arms and cling to life as they herd on his big brown, wool coat, only to melt one by one.

"We're all just snowflakes," I realized, a collection of molecules that take on a different form depending on what part of the journey we're in.

The farm's constant reenactment of the cycle of life is its gift. After years on the farm, I began to see death as a chapter of a life. Just as a snowflake went on to feed a puddle that filled a stream and then the river, the pumpkin patch is a gathering of molecules from my old goats, chickens, and cats, feeding the underworld of dirt creatures.

And somewhere, my father's ashes mingle with birds, air, and sea.

But life is for the living. And the many Misfits who came after Old Man Guinnias brought me more lessons, and more joy and purpose. One of those special souls was Mother Matilda. ❖

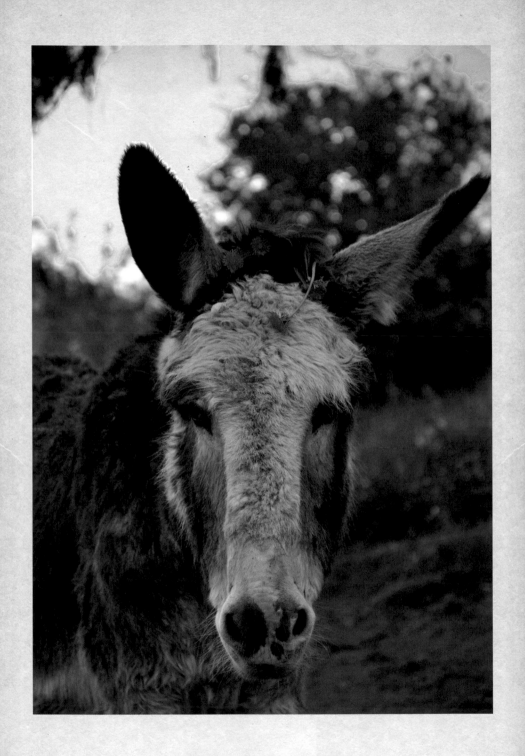

Mother Matilda
{Love}

Her job was to be a brood jenny even as she entered into her senior years. Living in neglect, she subsisted only on straw in a cold climate. Her fortunes changed after a donkey rescue found Matilda and eight other neglected herd mates. Eventually they connected with Apifera and she arrived after a day-long journey.

The old donkey who emerged from the trailer that day showed the strain her body had been put through. Her back was as swayed as a deep valley, her coat worn and ragged, and her feet split and chipped.

But her eyes—they were still full of her best asset—love.

She had the same name as my elderly mother—surely this detail was not lost on the universal forces in charge that brought her to me.

CONVERSATION
with Mother Matilda

"I remember her ear tips as they drove away," the old donkey said.

She was speaking about one of her many children.

"No matter where they took them, they came to the earth through me," the donkey continued.

They can't take that from her, I thought.

I put my arms around her neck and lay my head on her withers, looking back over her sagging spine. She didn't move, except for ear motions to redirect a fly or acknowledge a fluttering hay stem.

"I never watched them get in the trailer," she went on.

She reached over with her nose, touching an area of her back where scratching would be appreciated. I obliged.

"I could see their ear tips coming out of the trailer window as they drove off. They were pointed toward me," Matilda said.

She scratched her knee by nibbling on it with her wiggling, giraffe-like lips.

To say the soul is not a physical entity could be disproven by looking into Matilda's eyes. For there was a river of sentiment flowing from her glance into any viewer. I have seen it silence the outspoken, calm the over-energized, and touch the brokenhearted. Journeyers onto Apifera often write and share the more profound moments from their visits, which always include the simple phrasing,

"Matilda's eyes."

Arriving at Apifera, Matilda was placed in with the three resident mini donkeys. Her larger, white and brown spotted body must have seemed mythological to the gray minis who had never seen such a creature.

"She seems to have acquired spots somehow," said Pino, the first donkey of Apifera, when he initially saw her.

"She's very theatrical appearing," said Paco, quite a serious thinker.

On the day of her arrival to Apifera, the always observant minis cautiously gathered around Matilda. I took note that the spacing between each mini appeared to be equidistant. I sensed this might be some kind of donkey ritual, of which I know they have many. I did not ask and they did not explain, nor did they share what was said in the huddle. It lasted a minute, if that, and then the little ones ran up and away to their favorite spot on Donkey Hill. Now their mini bodies were little gray spots with tails prancing about, heads down in donkey play, but all the while they were looking back toward where Matilda stood, her sway back casting a shadow like that of a fertile mountain valley.

In the days to come, the minis treated her much like the Mother that she was. She groomed her little herd mates and they reciprocated, a charming equine behavior of acceptance. Matilda's first weeks at Apifera were spent in carefree fashion, sunning and adjusting to her new heavenly diet of hay, grass, apples, and animal crackers. Old growth savannah oak gave her shade and at night she was free to dream deep in a century-old barn that had proven to be full of much motherly love itself.

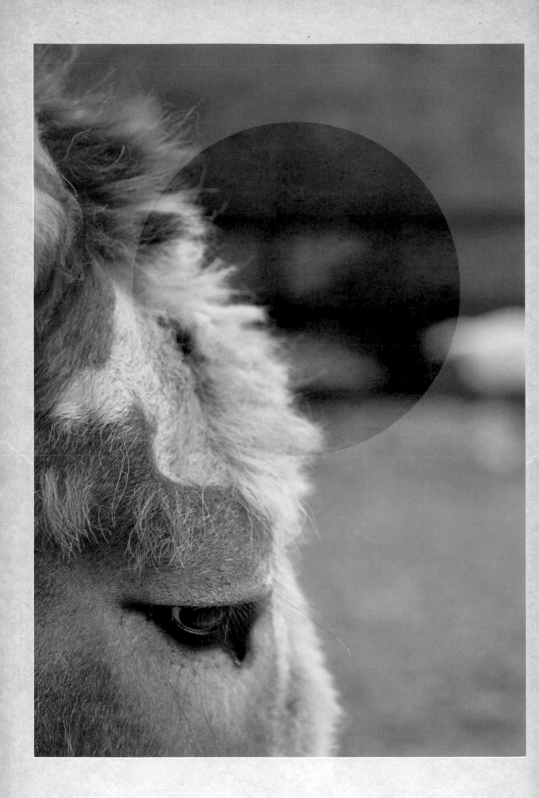

"My purpose was to be a mother. I am old now. My children are scattered," she said to me one day as I brought her berry branch clippings for a treat.

The conversation did not go past that, but as she chewed, I felt her searching for and then spotting the little clump of minis down near the stream.

Days turned into weeks, summer air became cool, with morning fog blanketing Old Barn. And one morning, the normal routine of the donkeys was diverted. I had gathered all the donkeys in a paddock and shut the gate behind me.

"What's this?" the minis queried, speaking in ear twitches.
"Is it shot day? Farrier day? So soon?"

Matilda's soul streamed into me, questioning me with concerned eyes and active ear movements. The last time she was herded up like this, she was put in a trailer and after hours and hours, landed at Apifera.

I reassured her without words, gliding my hands up and down her back and neck, but I was soon interrupted by the cars coming up the drive. Matilda stood close to the minis and observed the strangers walking toward them.

They were all very polite and quiet, and carried nothing that raised suspicion—no vials of medicine, no syringes in chest pockets, no halters with long ropes.

Once in the donkey paddock, the people walked all around, slowly, watching, listening, and drawing things on paper tablets. Many seemed to gravitate to Matilda, who stood motionless.

"I am here, come closer," the old donkey said with her eyes. "I will mother you."

They began resting their hands on her in silence, gently rubbing her shoulders or her mane and temples. Matilda acknowledged each person's space and then looked into their eyes, deeper and deeply. Some put their ears next to hers, others leaned on her body, running their hands on her curved spine of age and neglect, recognizing it as a sculptural sensation.

"I felt compelled to get close to them," Matilda told me later when everyone had left.

"They gazed on me like a Rubens painting of clouds," she went on to tell me. "They shared the symphonies that play in my ears," and she paused to eat some grass.

Her new purpose at Apifera was now sealed and she clearly understood her present and future task.

"I shall stand and be me, and love."

She slightly bowed her head before me so I could use it like a head pillow. We spoke not a word while clouds blew over Donkey Hill. ❖

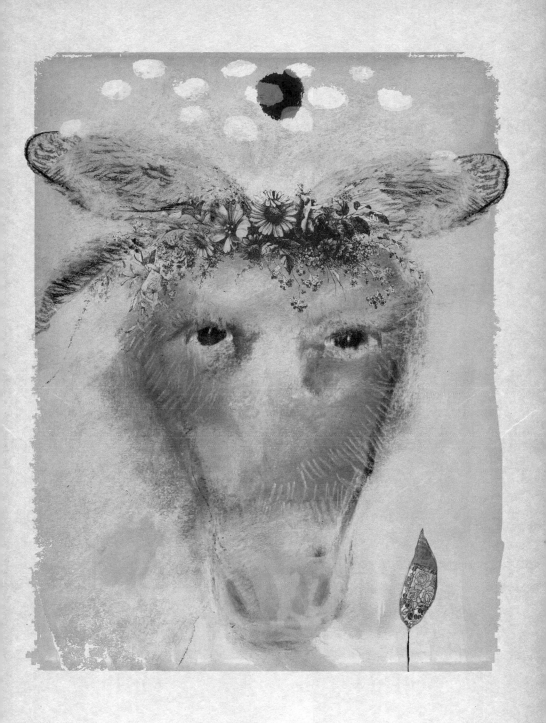

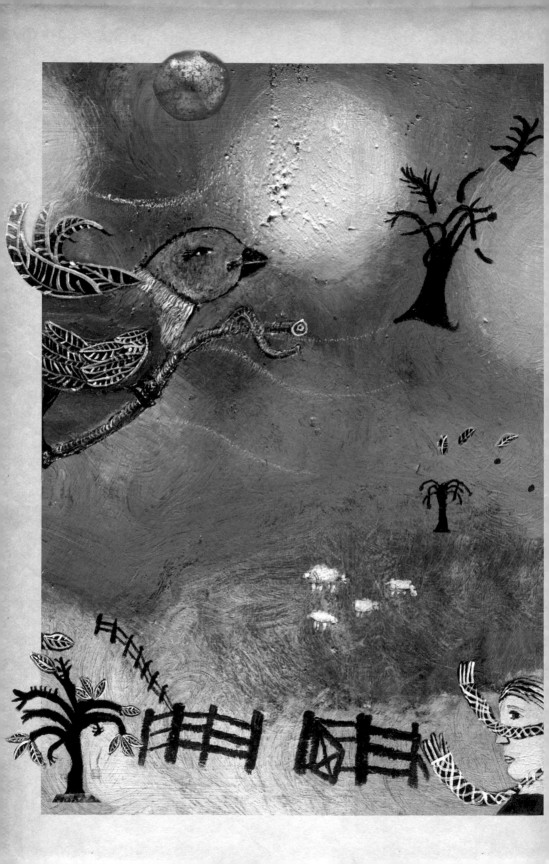

Memory
{Sometimes}

The morning I heard my father died, the intense sound of the wind was a natural soundtrack for the grey clouds moving quickly, like a video in fast forward speed. I felt small.

While I cleaned the barn that Oregon morning, the sound of the rain on the barn's tin roof carried me back to my Minnesotan childhood some fifty years ago, to a small shed also covered in tin. It was there I could sit with my dog and commune with the rain in a dry state. The memory made me yearn not so much for my father, but for a time when my world consisted of him.

While doing barn chores that morning, I sat down on a hay bale surrounded by semi-feral cats and cried. I held one of the few that would allow such closeness, but in seconds he leapt out of my arms.

"You can't keep anything," I said out loud.

I was far away from my father when he died, landlocked to my farm, without the resources or farm help to get on a plane on a whim to be there with him the day he died. How would my presence have helped or hindered him? For months, I asked myself that same question. After all, when an old animal was dying, I took care to stroke their ears and make them as calm as can be. I told them it was okay to go. I thanked them for living with me. I believed I was adding something to their passing to make it as good a transition as possible. But I couldn't do it for my father.

It took a one-day-old lamb's hospice and death for me to let go of the haunting I had been carrying with me for not being with my father on his death day.

"You can't save them all," an old farmer told me about lambs. "Sometimes, they just die, with or without your care." ❖

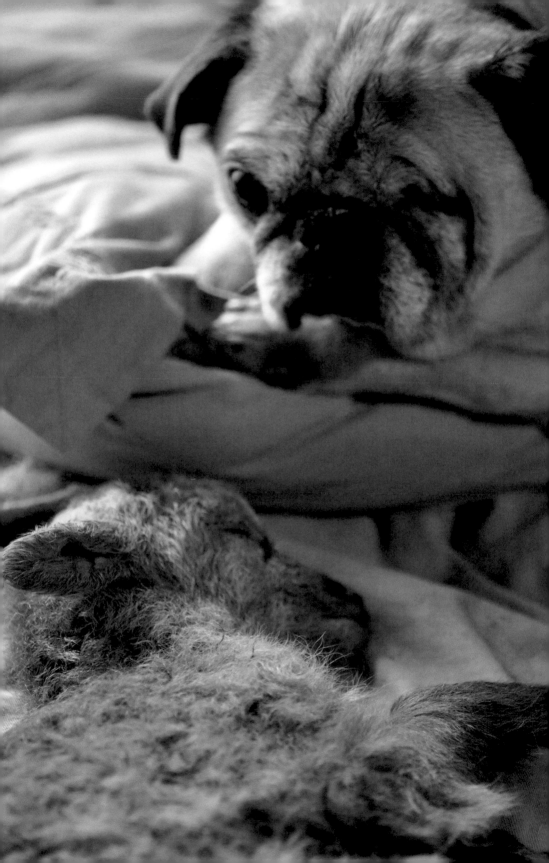

While the process of lambing is anything but gentle, it does bring new life. While the expected due date of the ewe is circled on the calendar, there is no way to calculate when nature might step in and bring death to a newborn, but it lurks each lambing season in the shepherd's heart.

The ages are mixed here at the farm. When I brought a dying newborn into the warm studio, it was the Old One-Eyed Pug who became her hospice nurse, along with a stray kitten.

My father had died in his home with hospice caretakers and my mother nearby, and his little dog most likely sleeping on the bed near to him. Being with the lamb as she lay unconscious, near death, I took comfort I could help her pass with companionship—just like my father, who died in the warmth of familiar surroundings.

The lamb did not have her mother. My father did not have his daughter. But both had something. They had care, and love. That is what is the most important thing. They were loved until the last breath, with conscious care.

Daisy, along with her mother Rosemary, were the first two ewes of Apifera, arriving with the flock's founding father, Joe Pye Weed. From the start, they made my life as a new shepherd easier—they were naturals as calm flock leaders, helping me learn the nuances of sheep language; they lambed and mothered without assistance, teaching me the basics of sheep rearing; and they tolerated my novice months as shot giver and foot trimmer.

I like all my sheep, but like any large diverse family of thirty, I have more of a connection and fondness for certain ones such as Rosie and Daisy.

When Daisy had triplets one year, the weakest was a little ewe lamb born with a striking white cap on her cocoa-colored head, just like her mother. Usually, the first forty-eight hours of a lamb's life are when things can go amiss and I had a feeling in my bones something wasn't right with this little girl. Despite my interventions, she weakened over her first morning and each hour she seemed slightly worse.

I have learned not to name lambs right away—for many reasons—but in my heart I named her "Little Daisy" and, while I never announced it to the barnyard, I whispered it to the mother sheep and her little prodigy. Naming an animal is a demonstration of my compassion for a fellow creature, and once that name is bestowed on an animal, my relationship with them changes for it marks the beginning of a sacred journey together. I sensed this little creature needed her naming now, not later. She deserved that respect.

I brought her to the warmth of the house since it was quite chilly and Daisy had to care for two other, bigger ram lambs. Despite more interventions, it was clear she was dying.

Experience told me she had hours to live, not days, and I placed her on the dog cushion at the hearth of the fireplace in my studio. The hospice group that naturally gathered around her did so without my encouragement.

The Old One-Eyed Pug, partially deaf and blind, warmed her body; Itty Bitty Etta, rescued as a one-pound kitten from a rural highway, observed and intuitively licked the lamb in gentle, surrogate mother strokes; and the chocolate lab named Huck held out his heart with attentive stares, his soul emanating from his deep, brown eyes. His compassion and concern hovered over the room, not only for the lamb but for the tired shepherd too.

Little Daisy lay in her cat and dog engulfed refuge, occasionally showing signs of life, but the fleeting life one sees in a flickering light bulb that hasn't quite gone dark. The hospice threesome showed no remorse or trepidation; they were simply present with the moment.

It was so quiet.

I felt compelled to document the moment, grabbed my camera but stopped, wondering if photographing this private deathbed was s piritually constructive for anyone. I sided with my muse and to this day the photographs take me to a place where fear of the unknown does not exist.

I can only hope such creatures are present when I lay dying. But if they aren't, perhaps I will be able to carry these images in my memory for comfort.

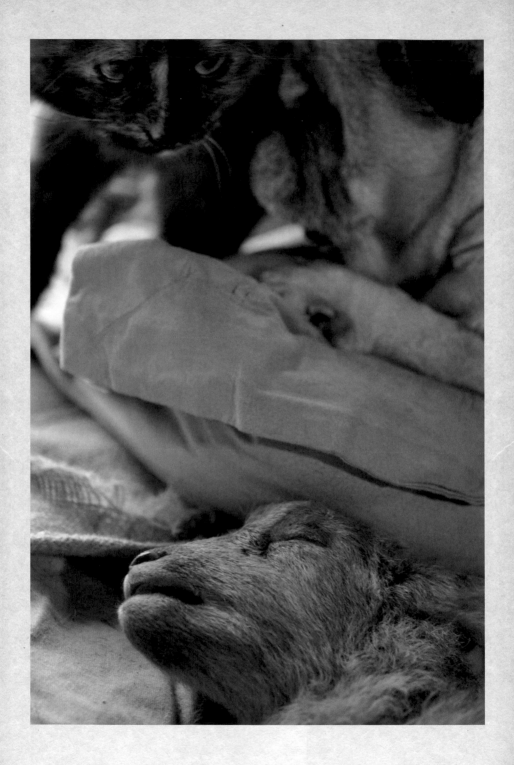

CONVERSATION
with the lamb

"I felt myself leaving the warm water, my legs were suddenly weighted down to hardness below me.

I was cold. My mother licked me over and over and over.

I tried to breathe this realm's air, but the cold filled me up.

My two brothers stood nearby but felt far away. My mother said a silent goodbye and I was half floating in the clouds above.

Floating in, floating out, and down and out.

She called me Little Daisy. It felt significant to have words that represented my chaos of minutes, even if they were often breathless.

I was listless in the hay and I felt a lifting of my body, high, and up and away, air streaming by me. Her voice was kind, but I just wanted her warmth, her warmth, her warmth.

I lay on a softness near a strong heat and I saw close up bits of creatures huddled with me. I was warm again on my outsides. They licked me as my mother had for that brief moment when I felt the earth and left the water.

It grew very quiet but my heartbeats were loud. She stroked my ears over and over and over.

And I flew away." ❖

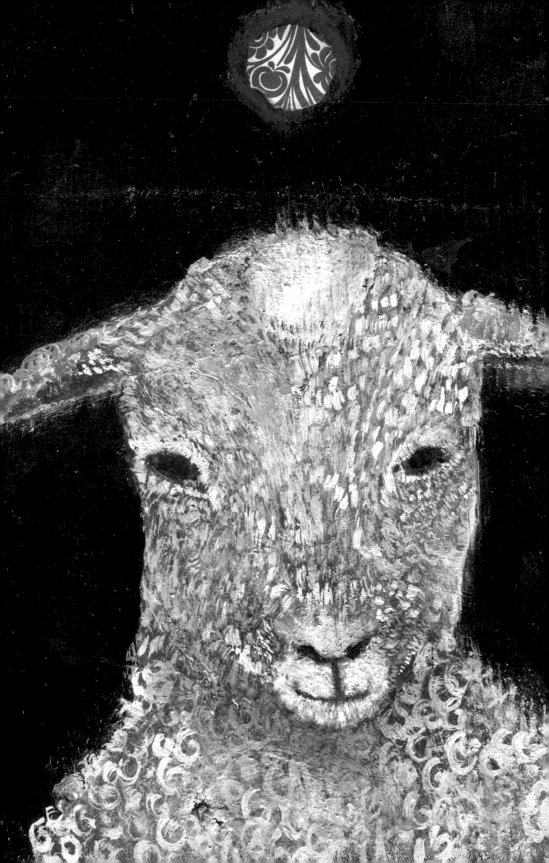

For Us

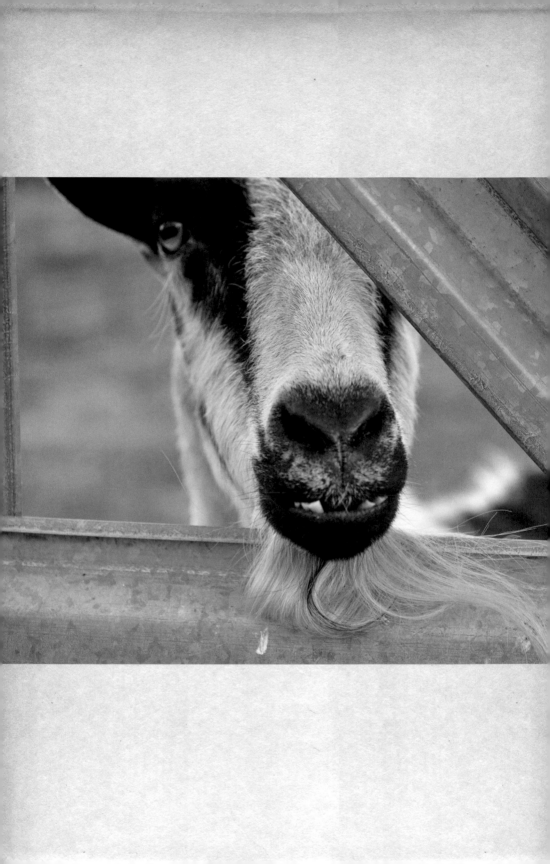

Honey Boy Edwards
{Purpose}

His back was parallel to my waist and his white beard blew in the wind like a model from a mural in a historical museum. He was a striking figure of black and white, strong even though arthritis had left his gazelle-like legs with a limp.

This big Alpine man had spent his life journeying as lead pack goat on wilderness hikes. He saw more of the Cascades' beauty than most of us will, drank from streams performing dappling water symphonies, and napped in valleys of English Daisy. I was privy to a selective account of his past life and I sensed a broken heart when he arrived. He'd lived with his second owner some eight years, packing and camping, but after his goat mate died she felt he would be better off in another home with other goats. It was during this time he almost died after accidentally getting into some azaleas —poison to goats—and surely this compromised his old system and would come back to haunt him . . . and me.

His given name of Lightning just didn't resonate with the creature standing before me. While Lightning might have suited his youth, he was entering a new phase of life at Apifera. Like an old bluesman, this goat had traveled the dirt roads, loved one or two women along the way, but lost them both through no fault of his own. Like any veteran of life, he soldiered on.

The name that finally presented itself was Honey Boy Edwards after his human Blues counterpart.

Honey Boy Edwards
{Purpose}

He towered above his new barnyard of pygmy creatures, handicapped
seniors, and a small pig. It was immediately clear he wanted one
thing—to be with me. When he partook in some bullying tactics in the
barnyard he did not always live up to the "honey" side of his name.
But with me, he was partner and long lost elder, who just wanted to
lead me . . . somewhere.

I understood his bullying the other creatures—he had a job for years
and, like any elderly gentleman, his transition to retirement left him
a bit confused and depressed. How do we heal the broken hearts of
old goats—and men—when their former lives abandon them?

Whenever I went to leave the barnyard, he ran the fence line,
crying. I'd never had a goat so attached to my presence. I needed to
reignite his confidence that getting up in the morning had more
purpose besides eating. I wanted Apifera to be a place of solitude,
not confinement, of his soul.

I took him on a short walk up Muddy Hill so he could feel like his
old packer self again. I have never packed before and initially I led
him like I would a horse on a rope, but it felt awkward and he seemed
anxious. So I let the lead loosen and he positioned himself in front
of me . . . and led.

It gave me the chance to see him in the same way he must have truly
perceived himself. He had returned to glory, if only temporarily, like
an old cowboy who gets propped up on a Palomino horse for a holiday
parade. I hope in my elder years I remember that day and that it
inspires me to keep doing things I know and love, even if truncated
by pain or stiff limbs.

As he led me on the hill, his expression said it all, "I am me again."

The uphill walk that day left him limping and stiff and I felt it was too much for his old structure, so I began certain rituals with him. When he greeted me at the gate, he would position himself slightly in front of me, but I kept my hand on his back and we walked toward the barn. If I stopped, he stopped. This daily task allowed him to do what he knew—lead.

Six months into his stay—without warning—Honey Boy became ill and I treated him with the normal routine for an upset rumen. That night, still not himself and agitated, I held his head, which calmed him, and I sang a very slow and quiet rendition of, "I Love to Go A Wandering," a song I loved as a child. He was falling to sleep as I left him.

"You're the leader," I whispered.

I found him in the same spot the next morning, already gone. I can be comforted, as should anyone who once knew and loved him should be, that I chose those exact words to say to him. He went out knowing he was a leader. He had his job until the end. How many of our elders—human or creature—can say the same?

The vet and I never truly pinpointed what happened. Would it have made a difference to know about his azalea poisoning and near death experience? Possibly. But perhaps that knowledge would have made me take heroic efforts he just wasn't physically or mentally prepared for at this late stage of his life.

As I pondered Honey Boy's demise, I recalled a conversation I'd had years earlier with a lifelong family friend who had turned ninety-three.

"How does that feel?" I asked, some fifty years his junior.

"I'm old enough," he said, "I've had a good life." He died later that year.

CONVERSATION
with Honey Boy Edwards

"Some vistas were more powerful than others," Honey Boy said.

"Do you remember all your journeys?" I asked him one day, as we sat far from the barnyard chatter of chickens, little goats, and teenage lambs.

"I suppose I do, in fragments. They come to me in fragments," he said.

He paused and, like a prophet stepping out of a biblical painting, his magnificent, white beard blew in the breeze and he added,

"My nights are alive with dreams and full of smells and sounds of fields and rivers. But the dreams have begun to linger into my days," the old goat explained stoically.

The old goat hit upon the startling fact all of us must face in our later lives—that our former days outnumber our future ones. I imagined being old, taken from my home and placed amongst others who through no fault of their own could not see me for who I really was or had been. How could they know all the journeys I'd been on and with whom, the art I'd made, the experiences that left scars or the ones that fertilized me to bloom and grow?

Perhaps memories, even if they come to us in bits and pieces out of proper sequence, serve to comfort us as we grow old, reminding us we are not defined from one day, but from a life of days.

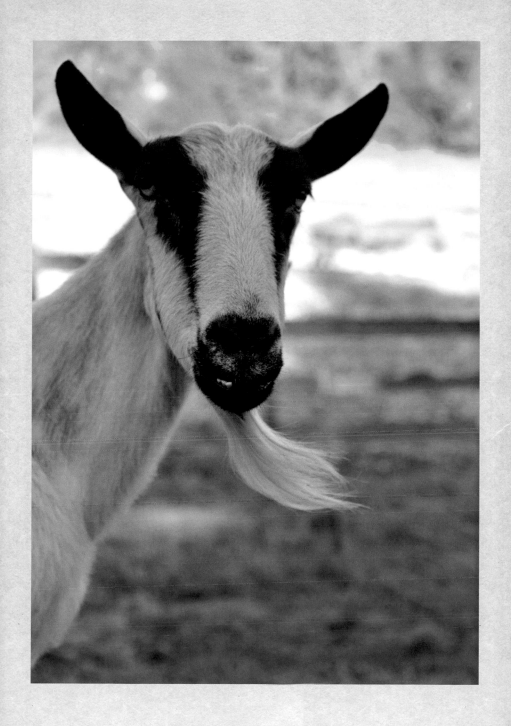

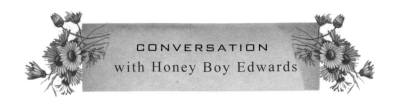

CONVERSATION
with Honey Boy Edwards

"Travel must deeply embed memories," I said to the old goat.

"New environments make my skin feel electric and I'm charged to see each leaf," he said. "A leaf on one trail was a different leaf on another. My journeys didn't allow me to become complacent. What I saw and felt is inside. How can I explain the sound of the eagles flying in tandem with me as I walked their cliffs?" he asked.

His words sent me back on a journey of my own.

"I did a road trip on the Minnesota River during March, when the eagles were in high nesting season, and hoped to see a few," I told him. "Within the first hour of getting there, I saw five juvenile eagles within fifty feet—and I figured that was my lucky break of the day. But by the end of the afternoon, I had counted forty-two eagles. One flew right by me as I walked a cliff, its wings made air move around me as it flew by. I always wanted to memorialize that day somehow, but never knew how. It's a memory only I can savor, since the person I was with that day is long gone," I said.

His beard blew again, and swirled back and forth until the air calmed.

"I guess we both got to watch the same universal movie," he said.

He continued, "We once had to choose between a steep incline on narrow path to get back to our campsite, or retrek for miles in the heat. I started for the narrow rock path, she followed, and just around the bend we came to a beautiful, clear, shaded pool. I sat on the rocks to shade myself while she swam. She crawled slowly along the pond's surface, inspiring water ripples to surround her in a halo of wet light," he said. "But she couldn't see it, only I could," he concluded.

He walked off, taking a path a little less worn by the other goats, but one that allowed him to stop on a small mound of dirt, where he stood to gaze out on what was now his final valley, the small barnyard he hardly knew.

I thought of my father in his final years, for he too had left his home to try living in Oregon to be near my brother and me. He was here two years before he and my mother decided to move back to their homeland of Minnesota, a terrain they understood, that held memory from various stages of their lives. I suppose it felt odd to live in a land without any memory attached to it, and at eighty-five plus it was too much of a challenge. I remember taking them out for a drive somewhere. I watched their faces in my rear view mirror as they gazed at the rugged Oregon terrain flying by.

Their thoughts were their own that day, and what memories they'd have of it would be out of my control, or theirs I guess.

Weeks after Honey Boy died, I arrived at the barnyard on a chilly, frosty morning to do my daily routine of chores. I walked the path, beaten down by chicken feet and muck boots, past the resting spot of the old white-bearded pack goat. The light frost that had covered his grave had begun to melt, leaving a ring of white light around his buried body.

"Just like a halo," I thought.

And only I saw it. ❖

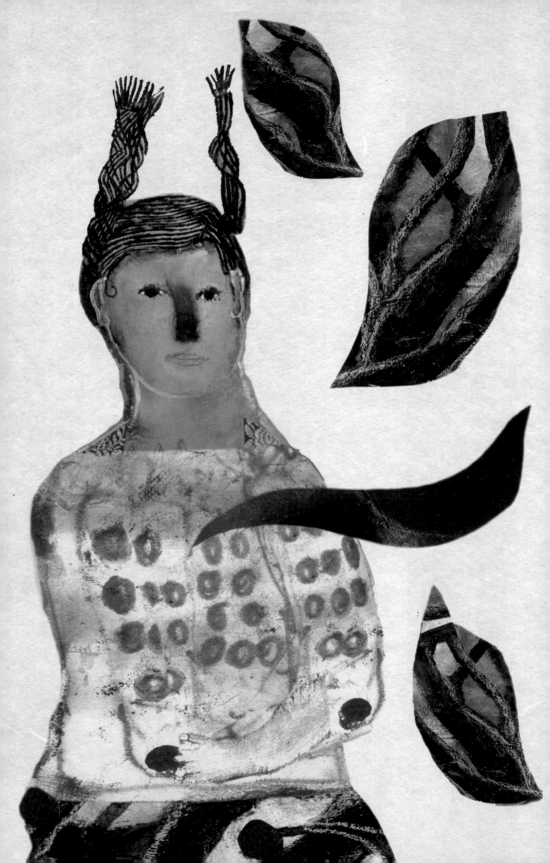

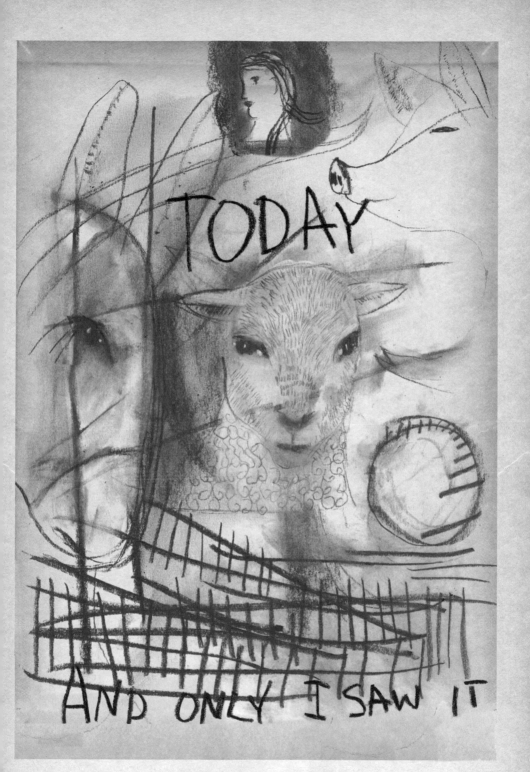

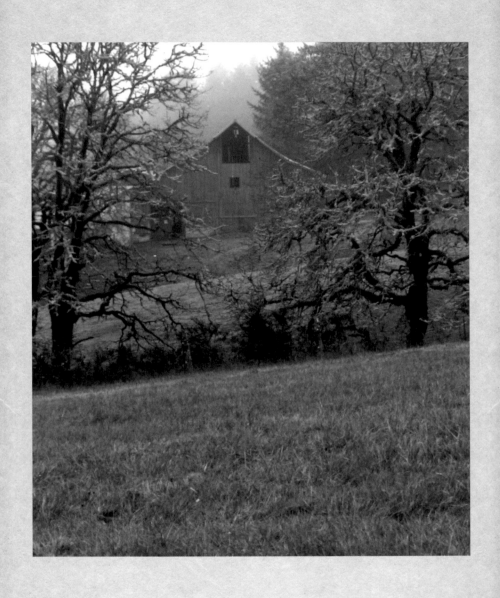

Dreaming Deep with Old Barn
{Carry on}

The first time I saw her, my heart beat faster. She was standing silently looking out at the pastures and stream she'd known for over one hundred years. And she was looking at me.

The wind-blown hay stubs floated to my feet from an upper loft in a casual invitation to step inside. A support beam creaked and a swallow took flight from bramble that was pressed against the barn's old body. Remnants of her former life as a dairy were everywhere—milk stands, hay twine, and burlap feed bags.

How many old cows have been born here under her care? I thought to myself.

I sensed some sadness on her part, but also pride and strength at living into old age. She reminded me of many an old farmer, calm while weathered, with one passion remaining—to live out their days with purpose on the land they loved, not as an old relic waiting to crumble, unable to be of service.

Those old farmers—how like my father they were. All of them just wanting to carry on, with dignity, as themselves. Like the old goats and donkeys who arrived here, they wanted shelter from storms, a place in the shade, and a warm spot for naps. They did not dwell on death, but hoped for a good one, I can only assume.

As I walked away from Old Barn that first day I met her, I heard a warm voice say,

"Dream deep."

She was a creature of few words, but it was the first of many conversations I'd have with her. I was a dreamer who helped even the wounded moth if I could. We were both caretakers of souls in bodies.

I had no idea she and I would work side by side with so many animals, old and young, helping some pass and encouraging others to live. But it was all part of my child dream and Old Barn knew it intuitively.

Just as I was enticed to move west by invisible wisdoms that guided me to my life mate—finally, in my forties—there were also internal powers guiding me to Old Barn, so she and I could work together with animal and land.

One of the last century-old barns in the area to still stand, she too had become a Misfit. Her kind has mostly been replaced by aluminum and metal that won't rot and can hold off fires. One person suggested we tear her down and sell her Doug Fir boards, using her concrete pad as a starting point for a new metal barn. But I approached her condition like the many neglected old animals who would someday make their way here—she just needed some extra sustenance and new support to make her limbs stronger. To this day, she stands in a state of elderly attire, rusted roof and faded red wood exterior softening in fog and lighting up in the sunset.

Unlike Old Barn, my elderly father could find no way to make his limbs stronger. His heart wore out on him; he was simply waiting for the wind to blow him over. He stood as long as he was able, he fought for life. Like this old barn I love so much, I admire him; he is a hero for all he did for me. I still feel him everyday—mostly in the wind. We speak through the wind.

Old Barn's life of service defines her and she has what many old creatures are missing—purpose and companionship. This is what I will hope for in my final days.

Like Old Barn, each old Misfit will stand as long as they have the inner strength to do so. And when they die, I will bury them in the pumpkin patch and celebrate them each autumn as I sit on the giant orange orbs of life. ❖

Each chas a past life
deserving of a mini memoir.

Each one can speak to
me just as Old Man Guinnias did.

Perhaps you can touch their
fur or even whisper in an ear
through a photograph.

❖

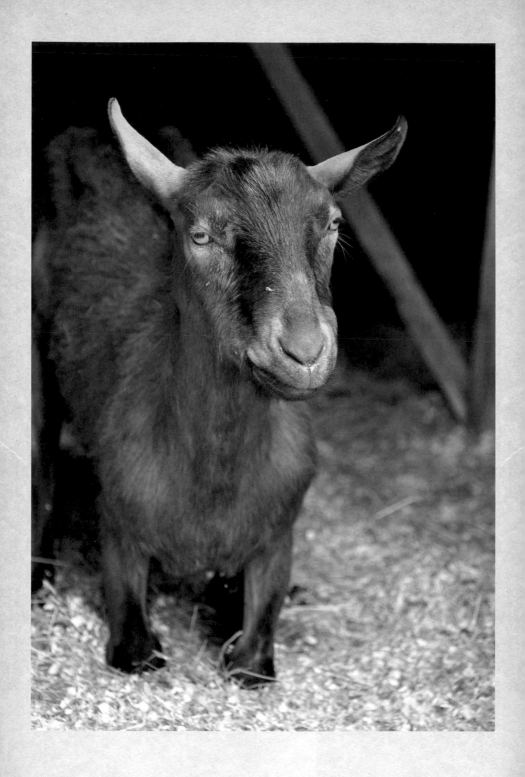

Stevie
{Dignity and gentleness while facing daily challenge}

He was living in Southern Oregon with a herd of thirty when he was rescued,but the damage had been done. His feet had never been trimmed, leaving him to eventually walk on his knees. This crippled his legs over time and when he was finally rescued, he couldn't straighten his legs. Through donations he was given an operation that would help him at least get up on all fours. To this day, he is most comfortable for long durations on his knees, but with daily pain medicine, he can walk, stand with bent legs, and graze.

Stevie is a gentle giant amongst the smaller Misfits. He gives small pecks—yes, kisses—with his closed lips on your face. He is the biggest of The Misfits, but never uses his stature to bully. After all the neglect in his life, he still trusts, shown by his ability to stand calmly for any strangers or vet care.

But what I see most in this gentle soul is his daily ability to just get up and start all over again, with steady disposition, even though he could have become cranky or despondent. He adjusts to any new arrangement in the barnyard, even if it means he has to switch beds or tolerate a new, young lamb. And let's not forget he befriended a grumpy little pig named Rosie who had no friends due to her curmudgeonly manners.

He faces his physical challenge without complaint or sourness, but with dignity and poise. He puts one foot in front of the other rather than just laying down in a heap of pity. He will do this until he can't.

Rosie

{Imperfect personalities can still bring joy}

It is said she was living like a princess in the home of an elderly
woman. And one day the old woman died, leaving Rosie to go to a
nearby sanctuary. When she arrived there, she was not too
pleased—no bed, but instead a barn with straw. While many of the
barn animals tried to get along with her, the little pig was not
interested in making friends—with anyone.

She was grumpy, and let everyone—humans and animals—know it.

But there was one animal who came and lay near her, a crippled goat
named Stevie, whom you just met on the previous page. And from that
day on, Stevie stayed with Rosie. It appears that both of them were
very open minded about the other—he didn't mind her mood swings,
and she saw nothing in him that was "different" or "handicapped."
And when Apifera asked to adopt the pig, they were thrilled, but she
had to go with Stevie.

To this day, years later, Stevie will often sleep near Rosie. But now
all The Misfits have learned that Rosie really isn't a threat, as long
as you don't wake her up out of a nap! Rosie delights guests with her
grumpy talk, her grumpy snorts, and her piggie walk. After months of
trying to understand why she was grumpy, I let go of needing to know.
I just accepted her as grumpy. She still runs to me when I call
her—knowing I might have a raw egg for her or slices of left over
apple. And she sits on my command, like a dog for treats. She does
pig stuff—like flopping on her side for a nap and belly rub. Pig stuff
makes a person happy.

When I greet her with scratches and she is in an especially grumpy
mood, I just tell her, "Oh my! Grumpy!" and we all go about our day.
A pig gets to be herself, as do you or I, even if we are grumpy for no
apparent reason.

Old Rudy
{Courage to adapt to a new life in old age}

Rudy spent his entire life in a loving home. The couple who owned him loved him a lot, but the man became very sick, and died. His wife kept their goats as long as she could, but eventually she felt they would be better in another home, since her life situation had greatly changed with the death of her husband.

So Rudy, age twelve, eventually arrived at Apifera with his lifelong friend, Tasha Teats. Rudy had developed serious arthritis as he aged, not uncommon for the short-statured goats, but he remained active and mobile.

If you looked up "gentleman" in the dictionary, you may as well just see a photo of Rudy. Never has a goat been so polite about medication, shots, and foot trims—not to mention his tolerance around all aged goats and a grumpy pig.

I see in Old Rudy a creature with courage—his life changed drastically, he lost his only home, said goodbye to old friends—but he went on. Without fuss, he went on eating, sleeping, and napping. He explored the barnyard like an elder gent might wander his new senior living complex—all the time thinking,

"Well, this isn't so bad, I guess. I'll make do."

Tasha Teats passed away. Rudy seemed to bond with another old goat, low on the totem pole. Then that old goat died. Now Rudy is both loner and joiner. I do not see sadness in his eyes. I see an old man who is here for another day, happy to have his hay and sun spot. He always talks when I enter the barnyard. And yes, he certainly reminds me of my dear departed Guinnias.

Aunt Bea

{Willing to fight for it, willing to let go}

A small herd of six pygmies was confiscated for neglect. They were very malnourished and were living in muddy conditions without hay or good care. The older matriarch of the clan was rounded in the belly, but if one touched her they'd feel her ribs and protruding backbone. Sadly, many a pygmy is left to this same fate—the owners see that round belly and seem unconcerned, but the goat is starving to death.

I named her Aunt Bea, and along with another pygmy in the group, she came to Apifera. I knew she was in pretty mediocre shape, and within a short time she seemed to weaken while the other pygmy was gaining weight. Blood work showed how anemic she was, and even after days of injections and vitamin treatments, she was not gaining ground. Her bone marrow just couldn't respond to treatment.

But the two of us—for those three weeks—we fought the good fight. Besides her injections and nutrition regime, she needed to be moved around as she had become so weak that she couldn't get up, and eventually she couldn't walk or stand. I created a sling for her so she could be held up to get her off the ground for short periods—being on the ground all the time is very bad for ruminants. I made her a hay wagon and wrapped her in old sweaters for warmth. I wanted her to make it. I asked her to make it. Her expression was always pleasant and her eyes were still bright.

On that final day, the vet checked her blood levels and they were worse. It was time to let her go. She went so quickly. She was ready. It was me that cried that day, not her. I am stoic around my vets, but this one was tough. My vet put his arm around me and said,

"You two fought so hard together."

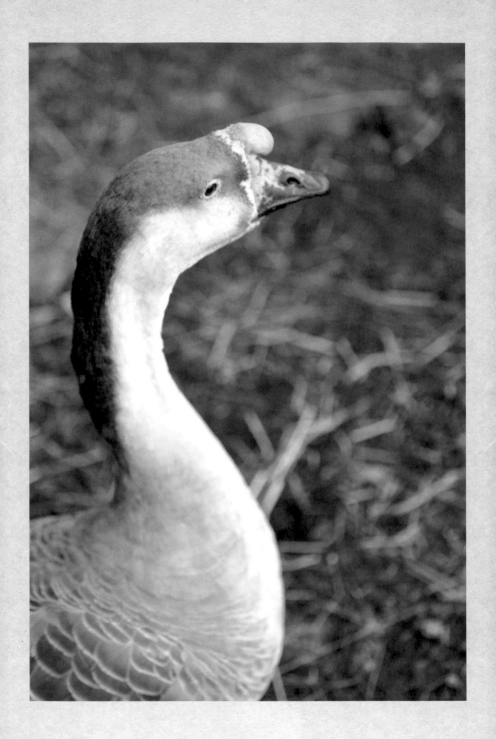

Priscilla
{Grace even when you fall}

Her owner's husband died of cancer, leaving her no choice but to
sell their farm. The old goose was twenty and she wanted her to go
to a safe home—with her flock of six ducks she had mothered and
protected since they were ducklings. We shared the same veterinarian,
and he suggested they come to Apifera.

The beauty of this creature is unmistakable. I often just watch her as
she drinks water, or sips through mud mash to eat the bugs, and I am
astonished at her graceful neck. That neck feels like it could break so
easily and I am able to stroke it without her fussing—what an honor
that she trusts me with her greatest asset.

She is old and she has limitations. She gets excited to eat at night
and will fall into her dish, but she always gets up and goes on, or
allows me to help her get balanced and moving again. She still is a
protector of her ducks, always leading them in a line with her wings
spanned outward—warning off wandering pigs and goats and letting
everyone know she and her "Bottomtums," as I call them, are coming.

Priscilla is as graceful as any ballerina, and she does it all with
webbed feet. When she sits on a nest of eggs, she preens the fallen
feathers and hay stems around her body, and her neck moves as if she
has been trained classically in movement.

I do not know how long a life she will have here, but to have her with
us showing such grace each day is a gift.

Granny
{Deformities do not hinder the soul}

Her former owners named her Granny because she was born with
missing teeth. Her tongue was unable to be held in her mouth
because of this, and the teeth she did have were crooked and deformed.

She was a small, thin goat, and never seemed very strong to me.
I really knew nothing more about her former life when she came to live
here. So I will talk about her life here at Apifera. She was content to
sit in the sun and since she had bonded earlier with Wilbur, that is
where you could usually find her. She always slept with her front leg
sticking out and she just kind of stayed out of everyone's way. But
she was no pushover and would stand her ground if necessary for food.

Granny's looks did not threaten the herd, nor were they a hindrance to
her daily life.

Her deformities did not define her. They just were.

After suddenly taking ill one day, I suspected poison. A vet was called.
We do not know what killed her, but there was no poison or substance
we could find that might have been the culprit. We treated her
immediately with emergency procedures, but she did not take to them
and we helped her on her way. I think it was her weak nature, and it
was just her time to pass on.

The Head Troll
{Some of us are natural leaders}

She arrived here with the name Taz, nicknamed for a vacuum cleaner, The Tasmanian Dirt Devil. I decided she was a tomboy at heart and named her Franklinia, a/k/a Frankie. She had been left out in the cold climates of a former home and her ear tips froze off. She had not been properly disbudded as a kid and her horns had been sawed off—a very inhumane way to deal with horns, which are just extensions of the skull. As unfortunate as those past experiences were, they gave her a distinct look.

From the moment she arrived at Apifera, she was in charge—of everything. She knew every fence hole, every gate exit, and had the ability to herd a flock or get to the head of a line before even the donkeys. She is fast. She is not cuddly and does not yearn for physical encounters with humans. But she is my right-hand woman. Over the years, she has become known as "The Head Troll," and nobody does anything in the barnyard without it being observed and analyzed by her.

Some animals—like people—leave a bigger mark on one's daily life. Such is the case with Frankie. She is my constant muse. Her lips do not move but I often hear her in my head and let her speak in my short stories—she always gets the job done quickly and without any pessimism.

I think one lesson of this wonderful creature is just that—she leaves an impression every day. I can't imagine the barnyard without her but the day will come. I expect her to haunt us all though, in a good way. I hope she does. But until then, she rules her empire.

Giacomo
{Seeking safe harbor to lay his head down}

Abused for years as a roping donkey in Texas, this elderly soul
arrived at Apifera with raw wounds on his legs and other scars. He
had the name Jack, and I renamed him with more dignity, Giacomo.

On his first day here, I saw blood in his urine and immediately
called the vet. No blood work had been done on him before his arrival,
and while waiting for results, I shared as much of my time with this
gentle soul as I could. He was hard to resist. His eyes were full of
love and trust, but also exhaustion. He liked to lie down with me and
rest his head on my lap.

The lab work revealed just how damaged his liver and kidneys were.
The vet felt most likely he had little water over the years. We just
don't know. But it was years of neglect that created the blood results
we faced.

Nineteen days with him was too short but he was suffering. On his
final morning, he started to walk to me, slipped and fell. He brayed,
but in a very longing, sad way. I sat down with him and he lay his
head in my lap. I knew he was suffering.

Nobody—nobody—will really understood what we went through
together those nineteen days, but we were bonded and still are.

He died with my arms around him feeling kindness. His grave is now
a place of comfort for visitors, as well as for me.

I truly believe Giacomo knew he was in a safe place where he was
ready to rest. And I believe he was meant to rest here. He showed me
you can trust even after you've been hurt. I will never forget this
creature, and he often comes to me in paintings.

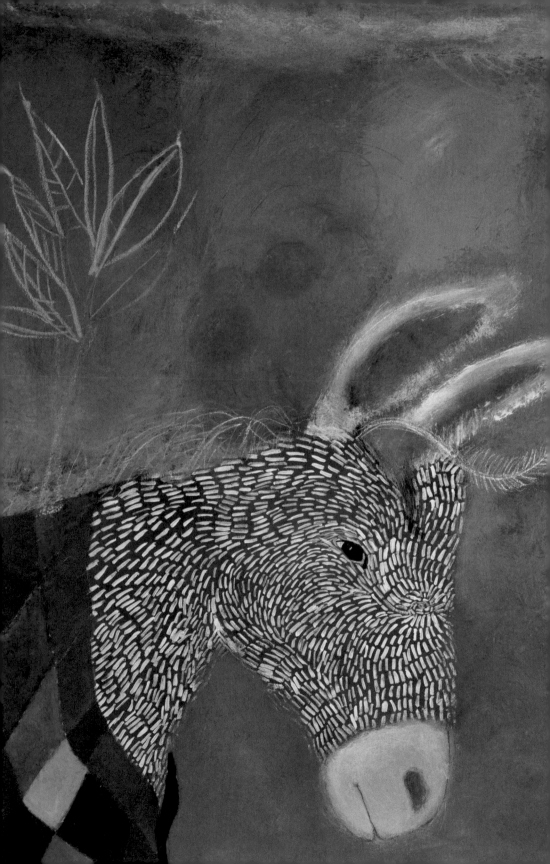

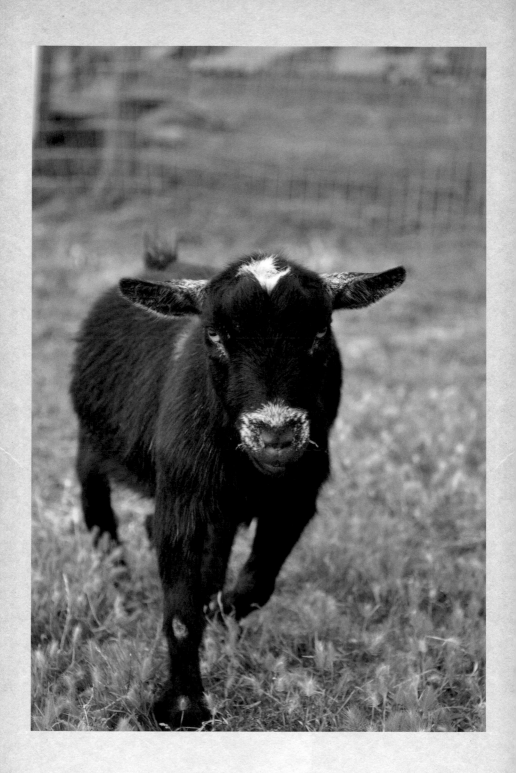

Lofa Love
{The weak often have the strongest love}

This odd little chap arrived thin and bowlegged from malnutrition and neglect. He had this way of holding his lips slightly open, showing some teeth, like he had poorly fitting dentures. He had a slow shuffle like an old man strolling the beach in Florida, looking for anyone to share some conversation with.

He was a lover. He would put his head on your leg and just stand—forever. Lofa was a talker—he greeted me every morning. He had a very unique bleat; it rang out high, a bit shrill so he was easy to recognize.

His past is unknown, but his condition was poor—thin, wormy, bad feet, and general health issues associated with lack of nutrition. Twice in his first months he fell ill, but I always pulled him through with vitamin injections and probiotics. But often the damage has been done after years of neglect.

One morning like any other, I arrived at the barn. And I screamed.

Lofa was dead. We knew he wasn't healthy, and he was always on a regime of shots, but Lofa's death was a shock, and so very sad. He could have had a heart attack, we just don't know. Usually I have some signs they are spiraling to death, but not this time.

He taught me something I already knew, but am reminded of when I walk into a barnyard without him. In the end, there is one thing left—love. The body deteriorates and decomposes, but the essence of the creature remains.

No matter how we are treated in life, under the right conditions we can bring out our love for others.

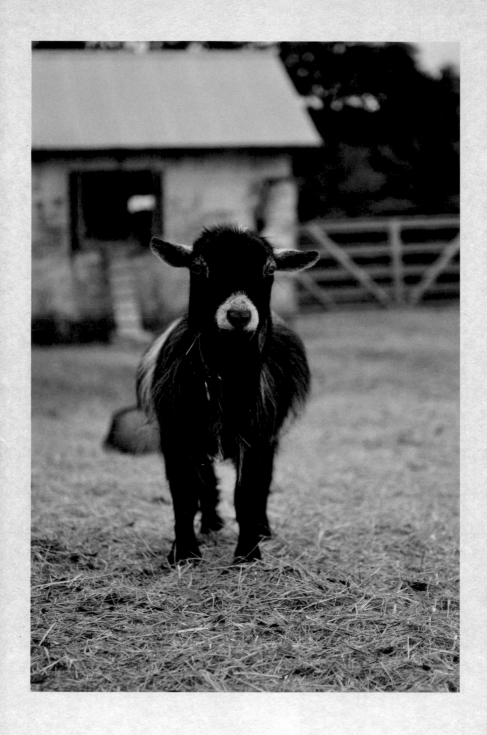

Raggedy Man
{Underneath is often a soul yearning for touch}

He arrived shaggy, thin, and pretty stinky after living as a neglected buck. He was wary of being touched and it took a lot of silent standoffs with cookies to get him to relax. He had no name but was such a shaggy mess I named him Raggedy Man. He also arrived with one of the sweetest smiles around.

Raggedy would watch from a safe ten feet as the other Misfits were brushed or scratched. I sensed a guy who really wanted that same back rub but just wasn't able to give in—fear from what, I wonder? Was he hit once? Or had he lived his entire life without human touch and just had to learn to understand its purpose?

Within time, his nutrition at Apifera helped his coat condition and we got some meat on his skeletal backbone and rib cage. Often people confuse the round belly of a pygmy goat with good health—but to the touch they are ribs and bones.

It took weeks to get Raggedy to stand for scratching—but when he did, he liked it. Then one day after a couple months, he came to me, without the reward of cookies, so I could pet him. He didn't stay long, but that was a lovely moment and I was so happy for him.

More rewarding is to see some of the young goats following Raggedy about the fields, as if he is the older uncle who knows everything. Raggedy is still cautious, but he is learning that getting love and touch is actually very nice.

How many people are never touched? How many elders are shut away without it?

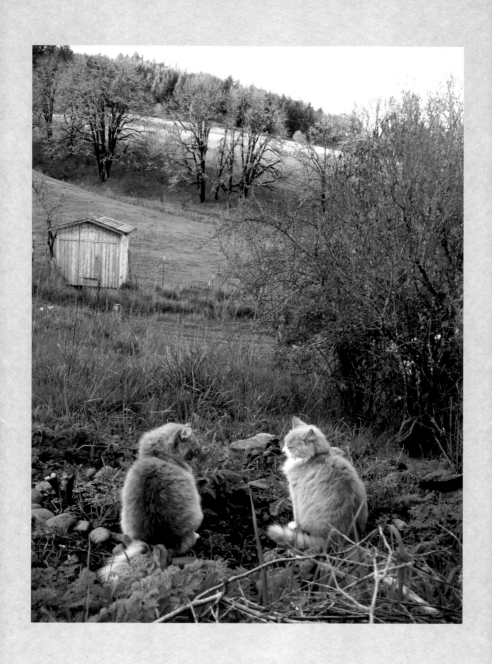

The Cats of Apifera
{Living in the moment}

We moved here to find a brand new litter of kittens in one of the barns. Such delight, of course! But then the task of trapping the mother and her young, and many roaming toms, to spay and neuter began in earnest.

The kittens were relatively easy, but the Mama Kitty was a survivor and it took me two years to trap her. In the meantime she had two more litters. Add to that the several adult strays who heard the living was good here, and we had a population of about twenty-five cats in two years.

Imagine if we had not trapped, spayed, and neutered them all?

The cats are wonderful companions to me, and to each other. Each one has developed into a distinct personality. Some are more personable, some have remained quite feral—including Mama Kitty, who lives on the front porch with two of her sons. To this day, nine years later, I have only been able to touch her once, on her nose. It makes me feel so good to know that all the effort and stress [for woman and cat] has allowed these felines to live long lives here. Some did disappear over time, but many are elders now, including the original mother and father.

Other cats have come into my life via rural roads and being in the right place at the wrong time, and all have stories and moments here that will live on in me.

Cats remind me to slow down, enjoy a moment for myself—like finding simple entertainment with a small piece of string. We lack for little if we truly live each moment with our surroundings.

Georgie and Gertie

{Sometimes old friends live and die as one}

Like two old sisters, they would live—and die—together. These two elder friends arrived very crippled, most likely from years of hoof neglect, and both were just not in the greatest shape. I don't know much about their former lives.

I think I often gravitate to the animals who just need a safe, warm place to die. That's how I felt about Georgie, the blonde goat. They both settled in just fine; their crippled state meant they basically napped and stayed out of the way. But Georgie became weaker and I knew she was failing. One morning I knew it would be soon, and she died that night. I checked on her hourly and was with her on her last breath. Within two weeks, Gertie died too. I'm sad to say I was not with her, but she died amongst The Misfits.

They are buried side by side in the pumpkin patch, entwined each summer in giant green tendrils and leaves.

Their time here was short, but I know they felt safe and loved here and perhaps had more attention those last months than in all their earlier years.

Death is not the worst outcome in many situations. It is just a new form.

They feed the pumpkins now and help worms grow for the chickens.

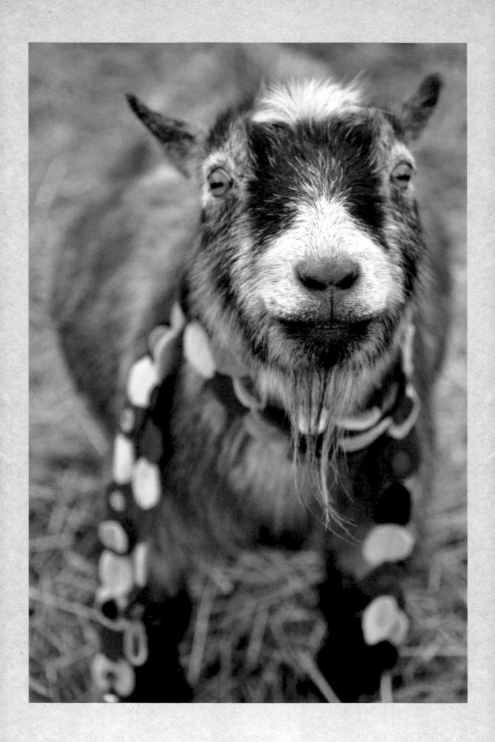

Professor Otis Littleberry
{Everyone deserves a name and a home that knows it}

He was part of a neglect case and had no name even though he was over eight. I put a lot of effort into choosing the right names for the animals here. While they might have a unique name known only to themselves, like a T. S. Eliot cat, for me naming an animal is my way to pay homage to them and their unique spirit while they are here on Earth.

So I gave him a dignified name, since he seems like a fellow who would wear a tweed jacket and teach American History.

Like many of the goats who arrive here, I treated him for anemia issues. He arrived out of the same herd as Aunt Bea, who couldn't pull through. But Professor was younger and perhaps had had a good home at some point, so he has made it this far.

What a delight this little chap is. Professor is willing to take orders, but is no pushover in the herd even with the bigger goats. He waddles, due to his bowlegs, which is often caused by long-term malnutrition.

He arrived nameless. But now he is Professor Otis Littleberry.

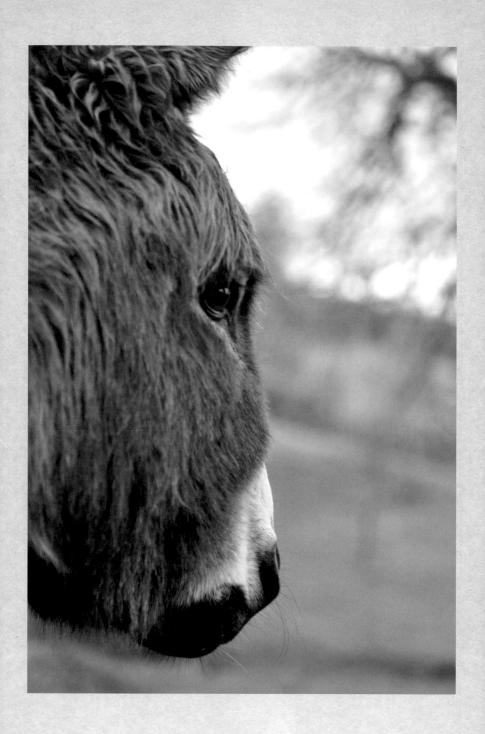

Paco

{Patience can nurture a gentle heart out of hiding}

He was living in an overcrowded petting zoo environment, amongst many ungelded donkeys and a menagerie of other creatures, when I adopted him to keep Pino company. Paco was not neglected, but I'm glad I could adopt him as he has found a wonderful life here in a smaller herd, with much more room to roam and play.

But the little donkey's insecurities took over the day he arrived and he was a real problem in his ground manners with people and animals. I spent two years working with this fellow and had many days wondering if I could ever tender him. It took four people to hold him down for feet trimmings, with each foot taking twenty minutes or more. He dominated anyone who came into his world, including me.

But I realized he was just insecure. He'd never learned any manners but was also pushed around by animals in his former world. He got here and I think he decided, "I'm going to be boss now."

It took time and patience, and trust and consistency on his end as well as mine, but we made it through and I'm so glad we did. Because the real Paco is so sweet, and funny. The real Paco just wants his rear end scratched. The real Paco understands now that foot trims aren't that bad, and if he stands quietly it all goes fast. I liken him to a poet, full of emotion that was displaced for a while until he found the right outlet to share it.

How many Pacos are out there—both animal or man—who just need some tendering and patience?

the
leaves
grew
as he
flew

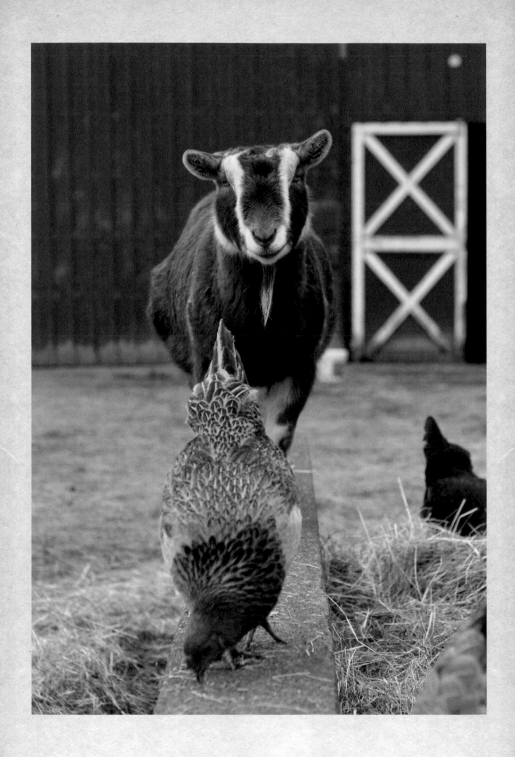

Wilbur the Acrobat Goat
{Let the young mingle with the elders}

I adopted Wilbur because I wanted to bring a goat on board who was healthy, young, and wouldn't die right away. I do not know a lot about his former life except that his owner's situation changed and he needed to be rehomed.

But it turns out that having a youngster flying around the barnyard is not only a gift to me, but to the elder Misfits as well. I see them sunning, content to watch the younger Wilbur jump about.

"I used to do that," I can hear them thinking. "But I'm content to nap."

Wilbur arrived with Granny and after she died I watched to see if he would interact differently. In some ways, I think it freed him to be himself and he began exploring more as he didn't sense a need to be at Granny's side. I've seen this several times with pairs—one caretakes and in the end that caretaking can become their weight. Wilbur is now independent, but plays with everyone who is willing, and when baby pygmies arrived recently, he finally had someone even younger than he. He will now get a taste of his own medicine.

Wilbur is lovely. He is still young at this writing, although entering middle age. When he is mischievous or rambunctious around an elder, I remind him he too will be old someday. It is hard to imagine, but he will get old, and I'll get old right along with him.

He can leap and twirl and skip and prance. When you see an elder walking down the street, remember they once had youth, and you will have old legs too someday.

Daisy
{The elder matriarch must always be celebrated}

I do not adopt sheep, because I raise sheep and want to keep a closed flock for health reasons. But as each ewe reaches elder status, I retire them to live out their lives at Apifera.

And one of our first matriarchs is Daisy who, at this writing, is ten. Daisy arrived at Apifera in our first year along with her mother, Rosemary, who died some years ago. The two have always been bonded with me and remain close to my shepherdess heart.

Daisy is symbolic of so much in a good mother, and leader. She is calm under very stressful situations—and sheep hate stress—and always looks to protect her young and care for them even after labor or a long day of nursing. She is polite yet strong. She ages gracefully, with salt and pepper coloring dotting her brown hair—but she holds her beauty.

She began her life here with the purpose of bringing life to us, because we chose to be as sustainable as possible on our farm. She did her job well and now her task is to graze and just be a sheep in the flock—but she still is grandmother and great grandmother to many, and sets a tone for the herd. Daisy still helps me herd the sheep in, even though she is now usually at the tail end of the flock due to her age.

She epitomizes "mother"—strong, reliable, loving, and warm to the touch when the nights are cold.

Like any mother, even when she is gone, she will be celebrated each time we greet her progeny. They in turn celebrate her sacrifices by living as their own creatures.

And all about us life floats on

Acknowledgments
{Thankful}

Many of the current and past Misfits wandered onto the farm through magical coincidences, or ended up in my arms through spontaneous encounters while I was minding my own business. Apifera Farm is not a rescue but is first and foremost a small working farm—some of The Misfits were originally rescued out of needy situations by the good work of Lavender Dreams Donkey Rescue {Washington}, Sanctuary One {Oregon}, New Moon Goat Farm Rescue {Washington}, and Peaceful Valley Donkey Rescue {National}.

Thank you to everyone who donated to the fundraising efforts of this book and to all who have encouraged me to keep going. I am also sustained by the people who buy my art or sell it at their galleries. I am always humbled by those—many, strangers—who donate to the emergency needs and maintenance of the adopted Misfits and to the people who volunteer their time at the farm when needed.

To Martyn, a/k/a The Dirt Farmer, thank you for letting me follow my heart. Without you, Apifera would fall down, and I would float away.

To my parents—thank you for life, love, and nurturing. I miss you both each day on multiple, quiet levels.

And to all the creatures who come and go here—thank you.

www.apiferafarm.blogspot.com
www.katherinedunn.us
katherine@katherinedunn.com

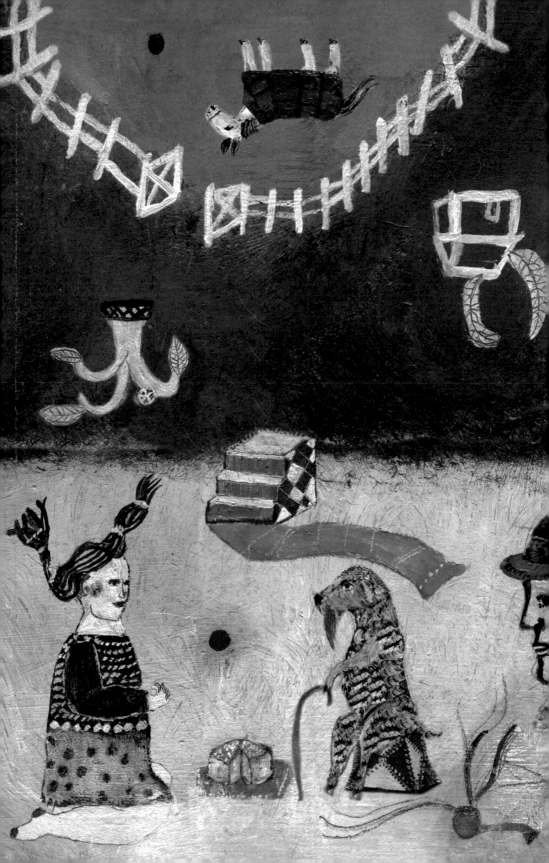

And they
never parted

R

G